MERMAID LIFE

MERMAID LIFE

The Joy of Making Waves

CHRISTINE DE CARVALHO

WORKMAN PUBLISHING · NEW YORK

Library of Congress Cataloging-in-Publication Data is available.

ISBN 978-1-5235-1073-3

Design by Sarah Smith

Author photo by Alan McGinnis

Workman books are available at special discounts when purchased in bulk for premiums and sales promotions as well as for fundraising or educational use. Special editions or book excerpts can also be created to specification. For details, contact the Special Sales Director at the address below or send an email to specialmarkets@workman.com.

Workman Publishing Co., Inc.
225 Varick Street
New York, NY 10014-4381

workman.com

WORKMAN is a registered trademark of Workman Publishing Co., Inc.

Printed in China

First printing February 2021

10 9 8 7 6 5 4 3 2 1

THANK YOU

To my husband for unconditional love and support.
To my family for believing in my dreams.

And to mermaids and dreamers everywhere:
Never stop believing in magic.

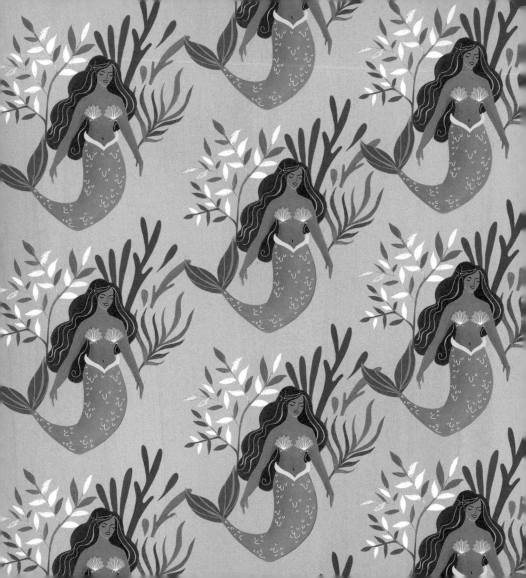

MERMAID

[ˈmər-ˌmād] *noun*

1. A legendary creature of the sea with the head and upper body of a human and the tail of a fish.

2. A majestic being whose passion knows no limits.

3. A beach babe who can't stay away from the water. When landlocked, they are often found relaxing by the pool or luxuriating in a warm bubble bath.

The truth is, merfolk haven't always had the best reputation. According to mythology and folklore, mermaids were known to sing to sailors, luring them to their doom.

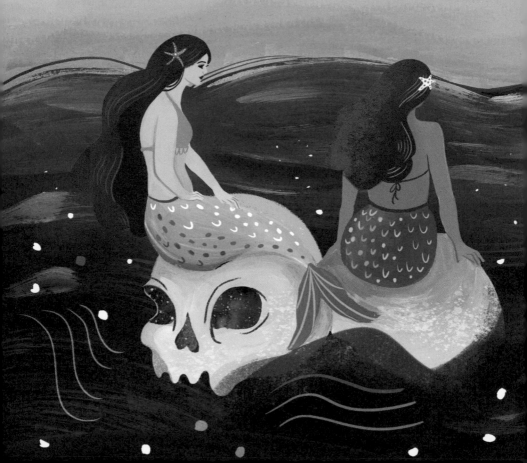

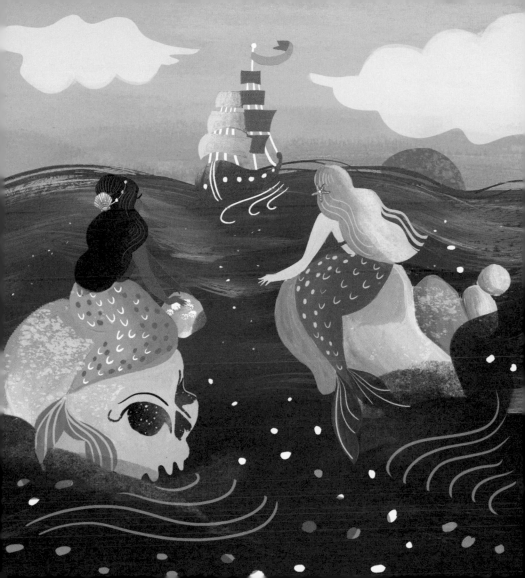

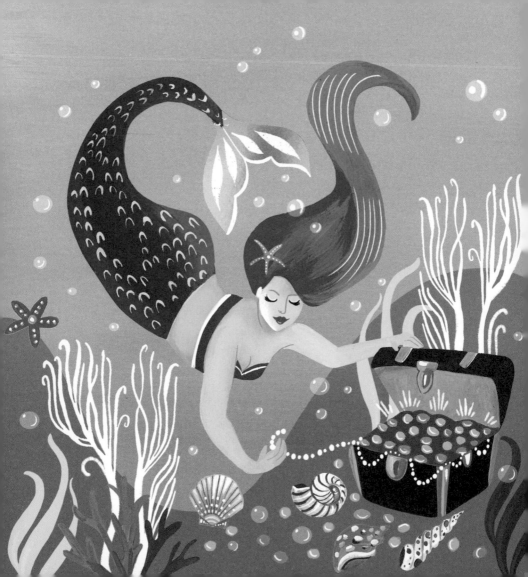

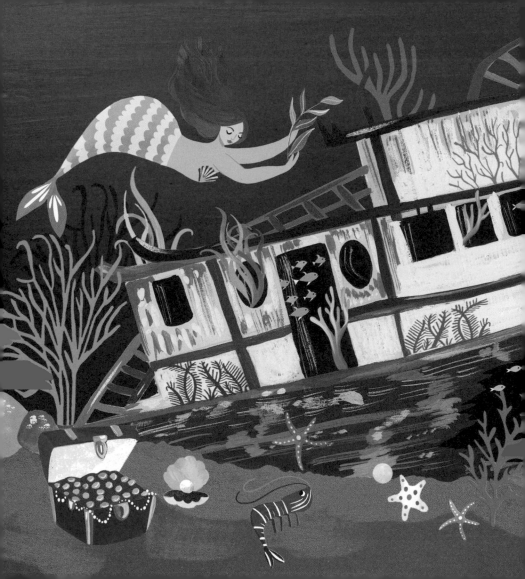

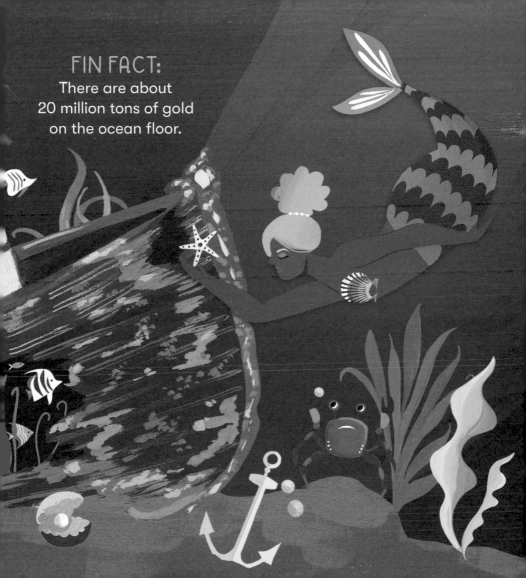

FIN FACT:
There are about
20 million tons of gold
on the ocean floor.

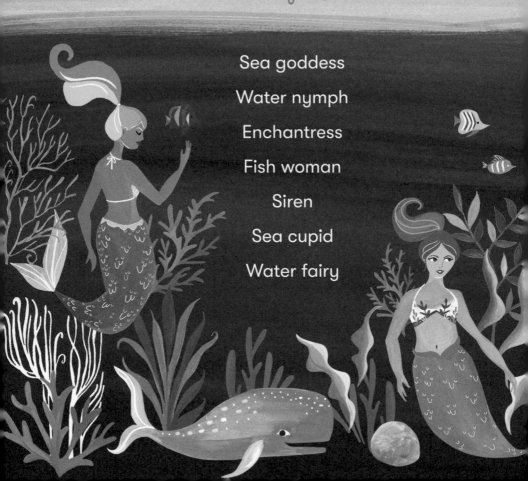

OTHER NAMES *for* MERMAIDS:

Sea goddess

Water nymph

Enchantress

Fish woman

Siren

Sea cupid

Water fairy

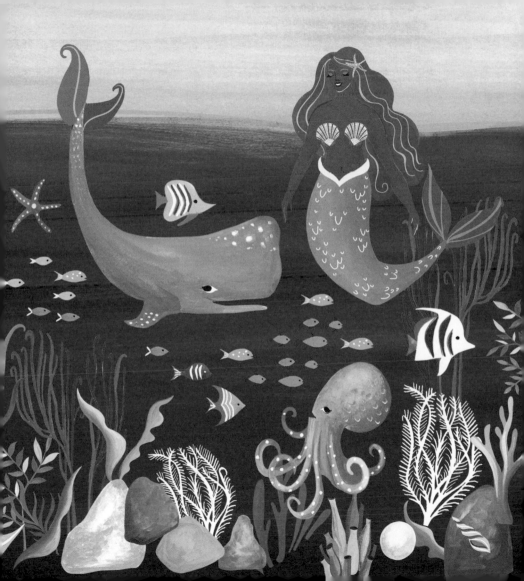

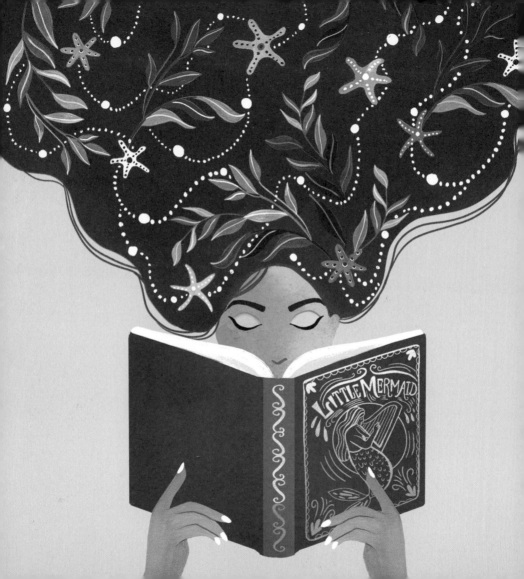

"The Little Mermaid"
is one of Danish author
Hans Christian Andersen's
best-known fairy tales.

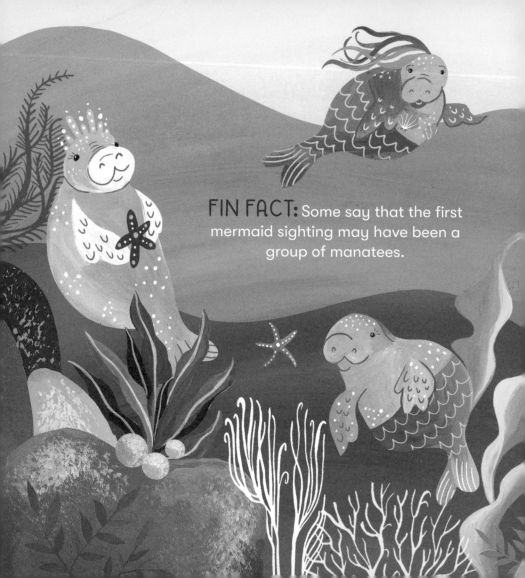

FIN FACT: Some say that the first mermaid sighting may have been a group of manatees.

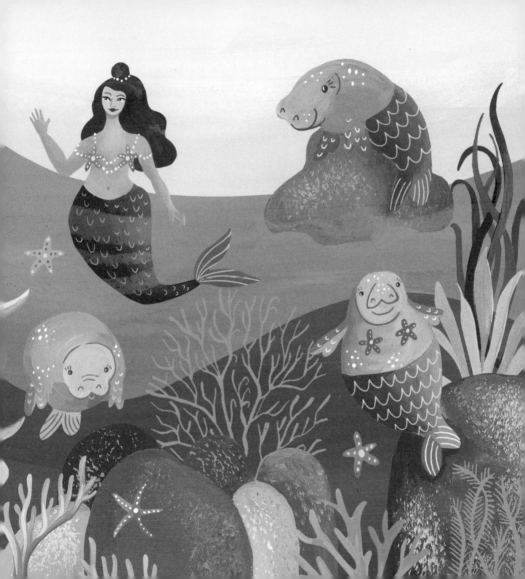

MARMORIS

['mär-mȯr-əs] *noun*

1. The shimmering surface of the ocean

2. The magnificence of light glittering on the sea

3. The ocean's resplendent shine

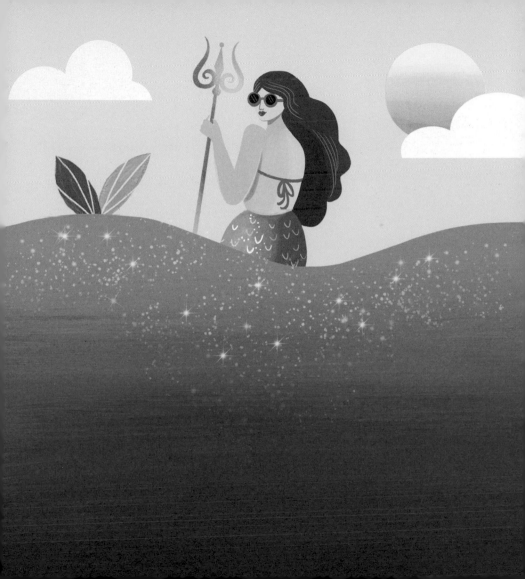

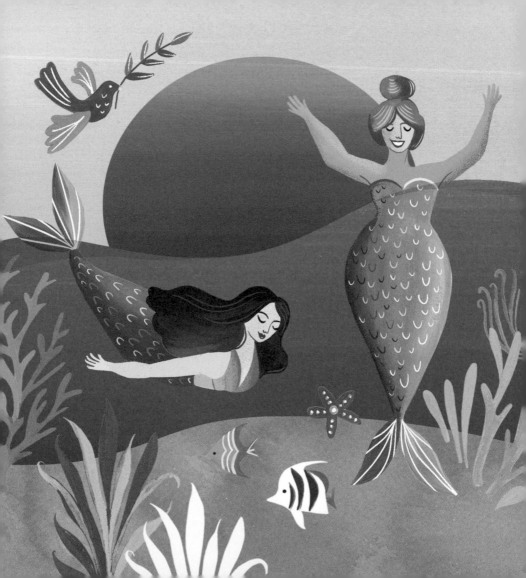

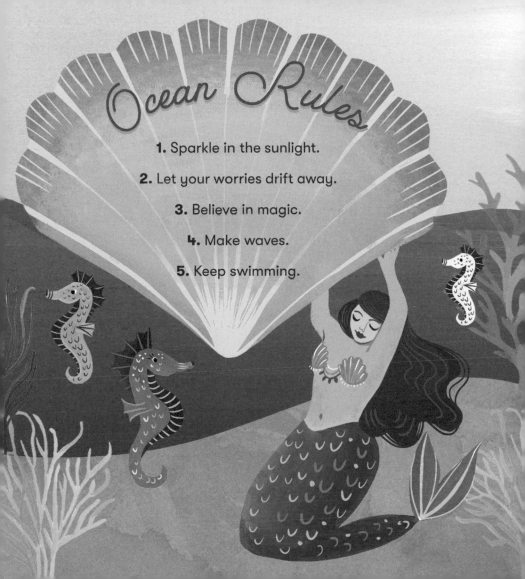

Ocean Rules

1. Sparkle in the sunlight.

2. Let your worries drift away.

3. Believe in magic.

4. Make waves.

5. Keep swimming.

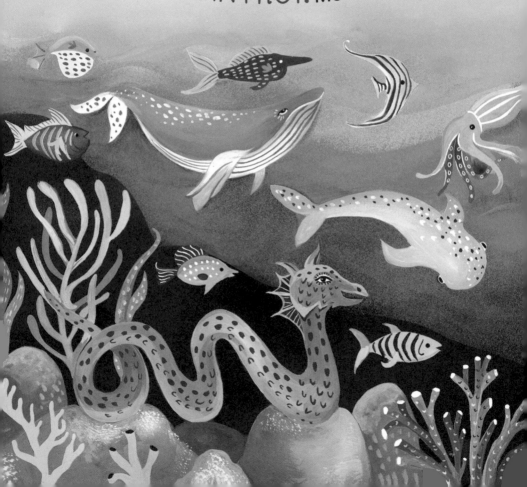

e Earth's oceans is unexplored.

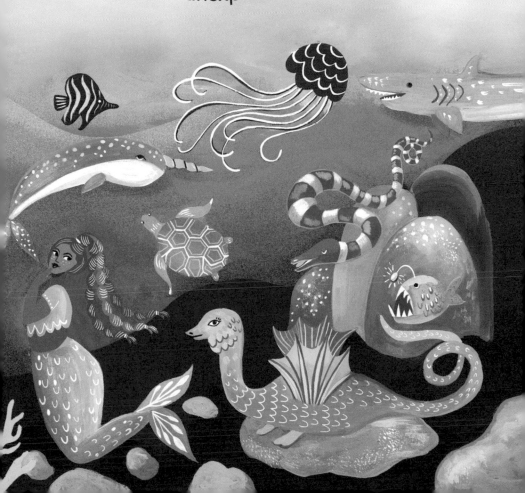

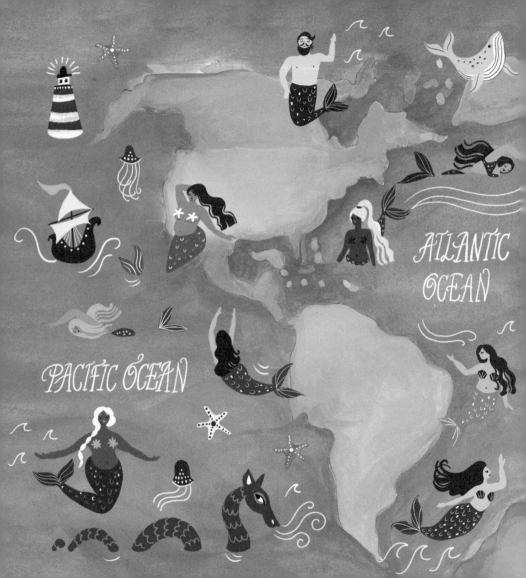

ATLANTIC OCEAN

PACIFIC OCEAN

ARCTIC OCEAN

INDIAN OCEAN

SOUTHERN OCEAN

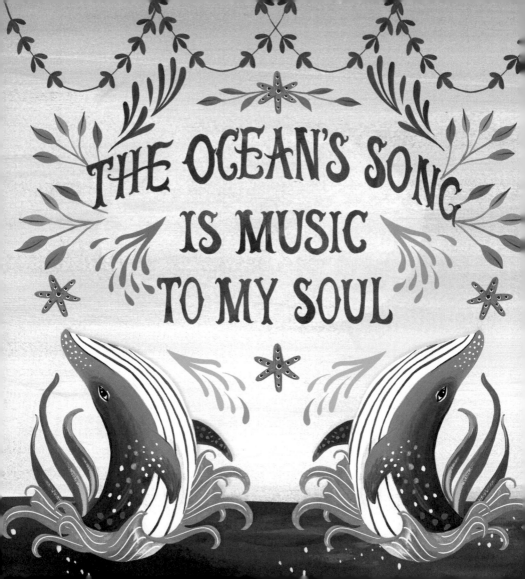

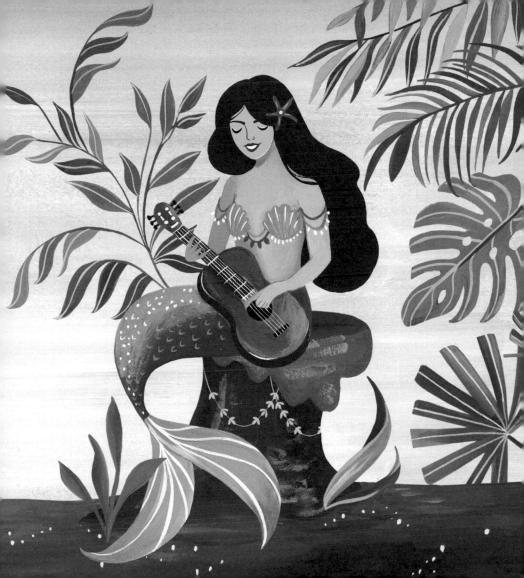

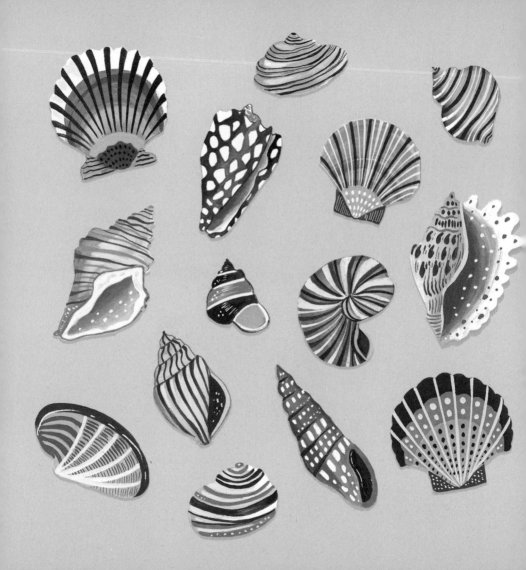

MER-MAZING

[mər-'mā-ziŋ] *adjective*

1. Extraordinary

2. Out-of-this-world incredible

3. Mesmerizing to behold

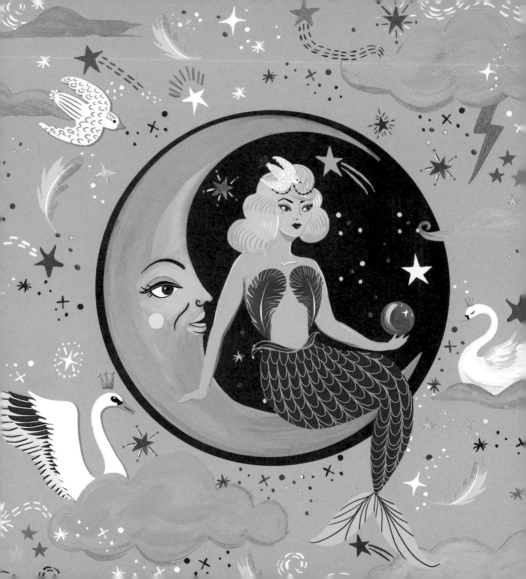

The universe is full of Magical things.

—Eden Phillpotts

Sea witches are mermaids who carry with them a distinct belief in their own power and strength.

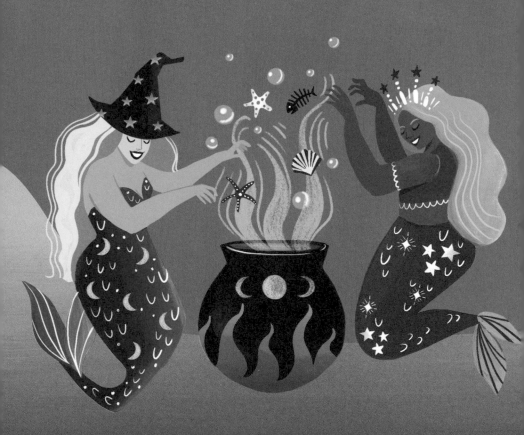

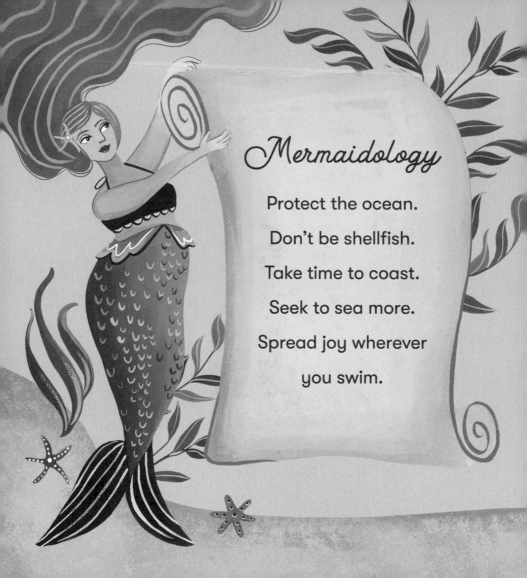

Mermaidology

Protect the ocean.

Don't be shellfish.

Take time to coast.

Seek to sea more.

Spread joy wherever

you swim.

Mermaids are known for their enviable superpowers, including immortality, clairvoyance, telepathy, and hypnosis.

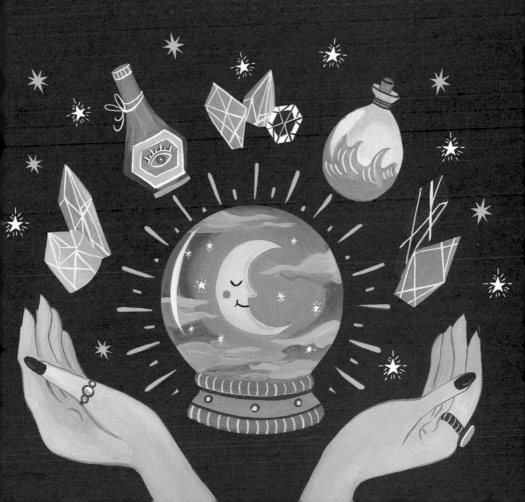

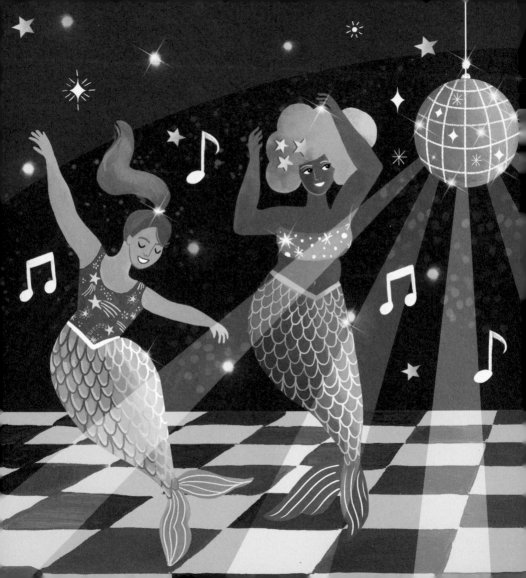

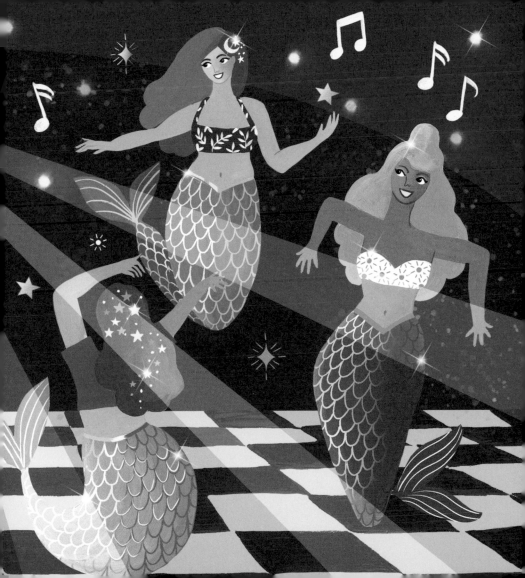

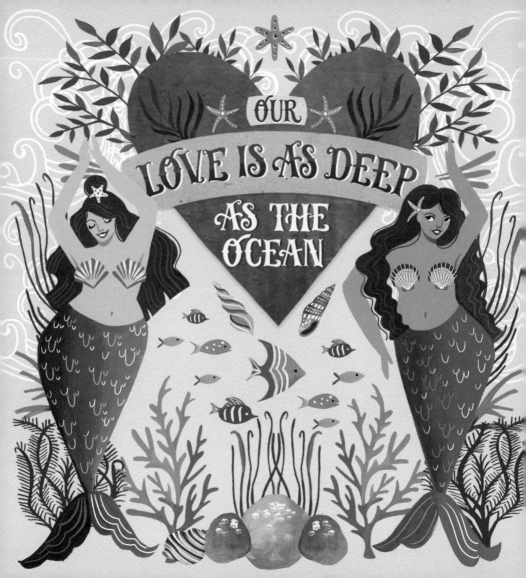

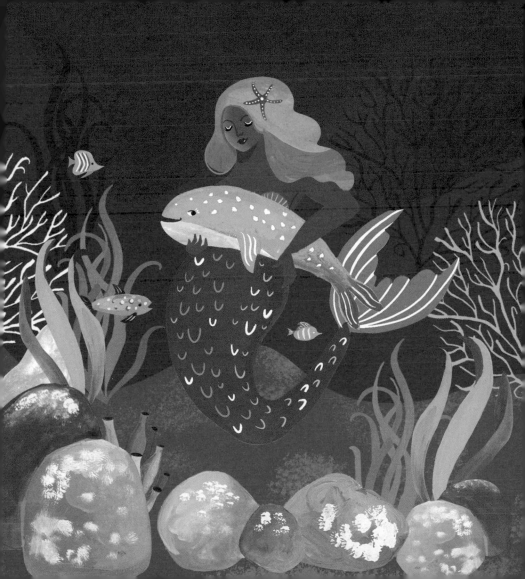

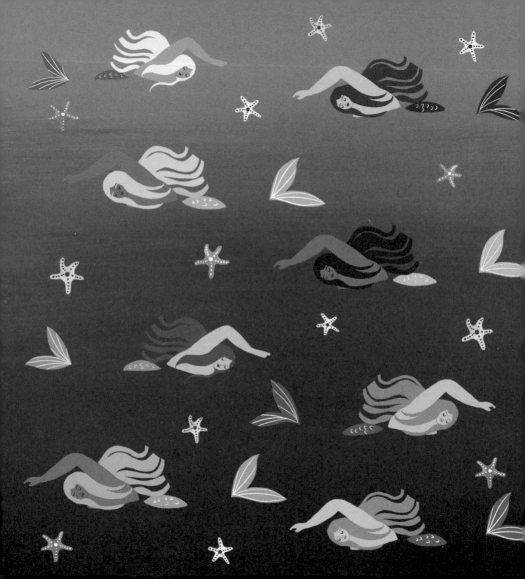

THALASSOPHILE

[thə-'las-ə-fī(-ə)l] *noun*

1. A lover of the sea

2. A person who daydreams about being at the beach

3. Someone who has an obsessive desire to swim in the ocean

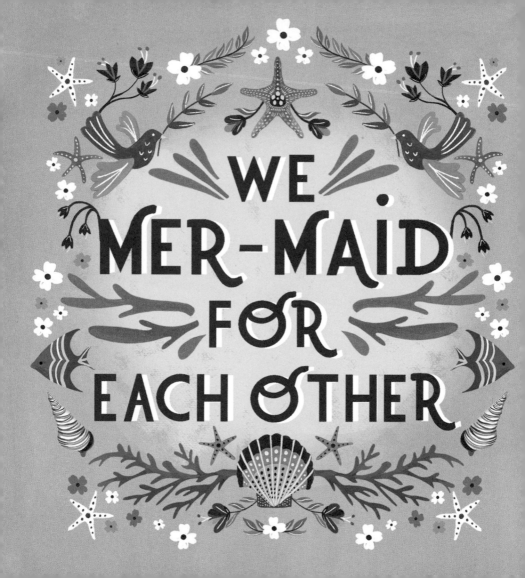

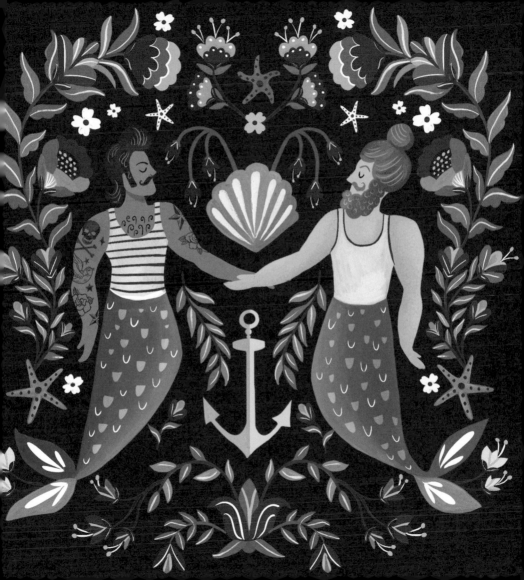

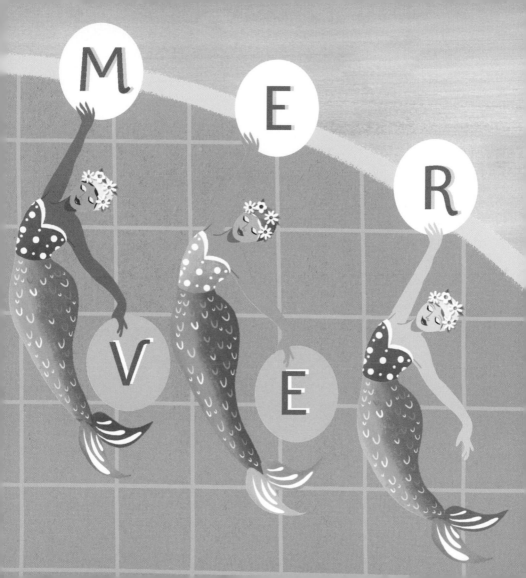

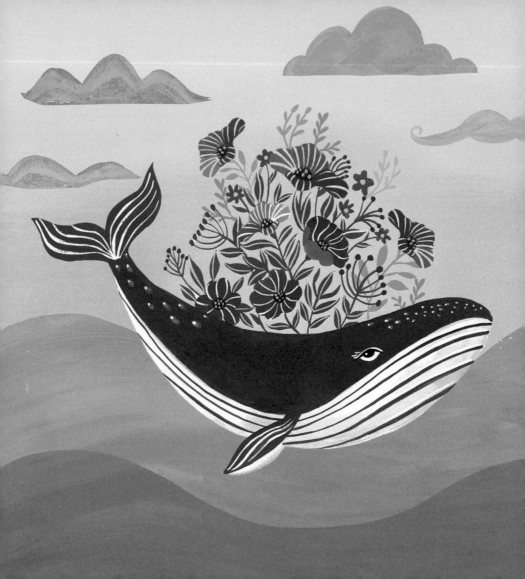

Feeling Fintastic

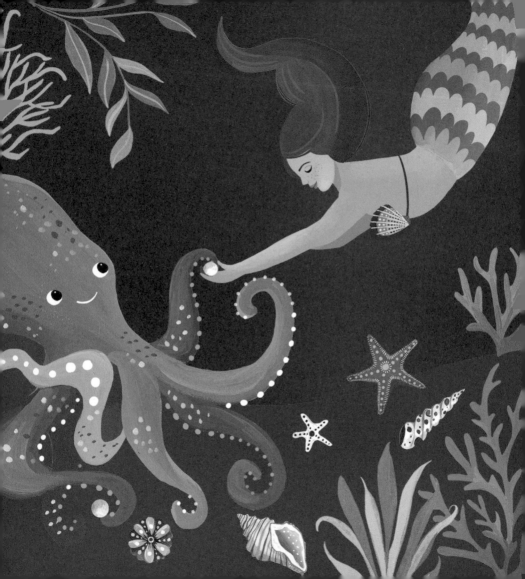

FIN FRIEND FACT: Octopuses have three hearts. They're also known to decorate their dens with shells, stones, and other shiny objects.

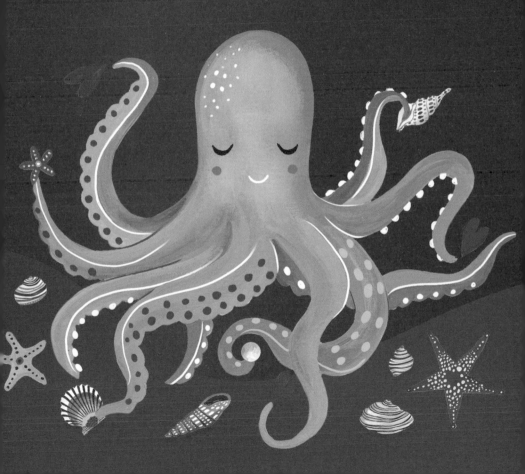

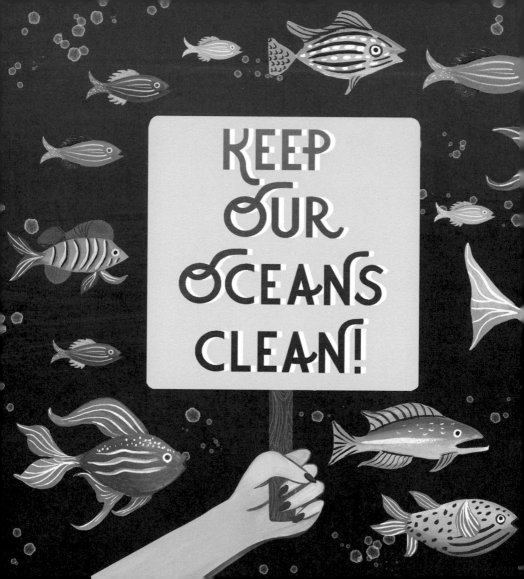

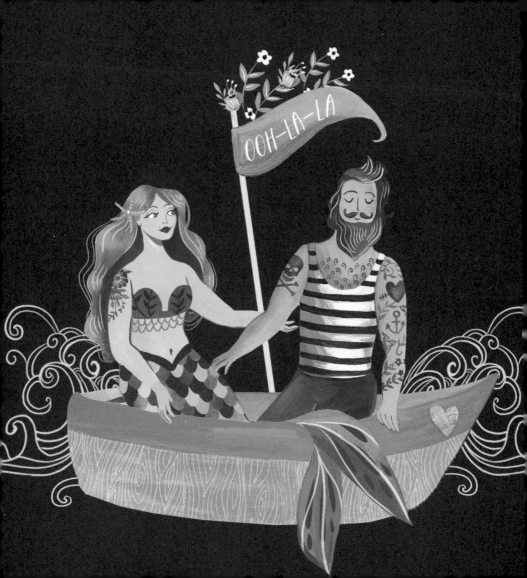

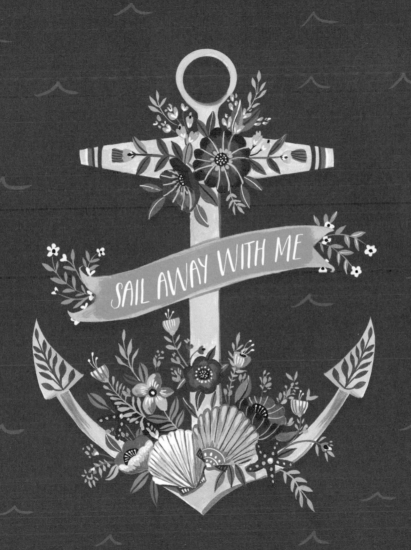

Mermaids have many modes of transportation and don't rely solely on their fins.

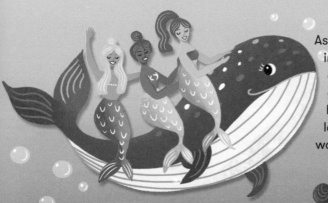

As the biggest mammal in the ocean, the whale can transport an entire group of merfolk on its back. Ideal for mermaids looking to catch up on the way to a party.

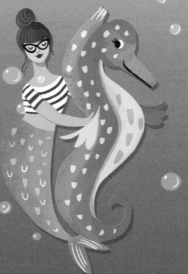

Though considered a somewhat antiquated mode of transportation, the seahorse is making a comeback and is being increasingly used by hip mermaids everywhere. Ideal for anyone wanting to make an impression.

The clownfish is a reliable, friendly, implausibly spacious, and speedy form of transportation, perfect for the on-the-go mermaid.

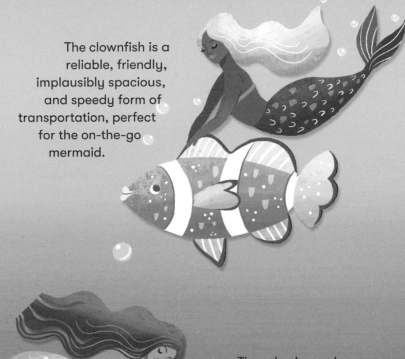

Though wise and great with directions, the sea turtle is not known for being prompt. Ideal for mermaids aiming to slow down and enjoy the view.

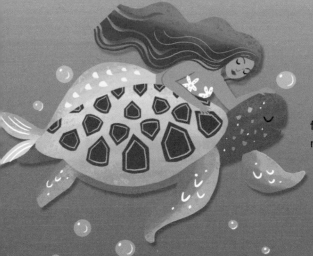

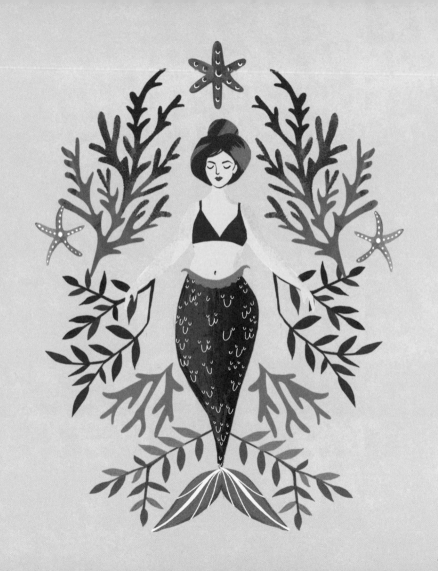

EUDAEMONIA

[ˌyüdēˈmōnēe] *noun*

1. A contented state of being happy, healthy, and prosperous

2. Greek word for "#blessed"

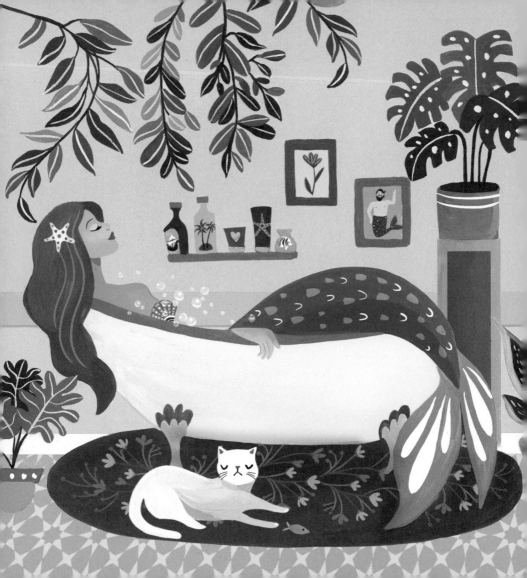

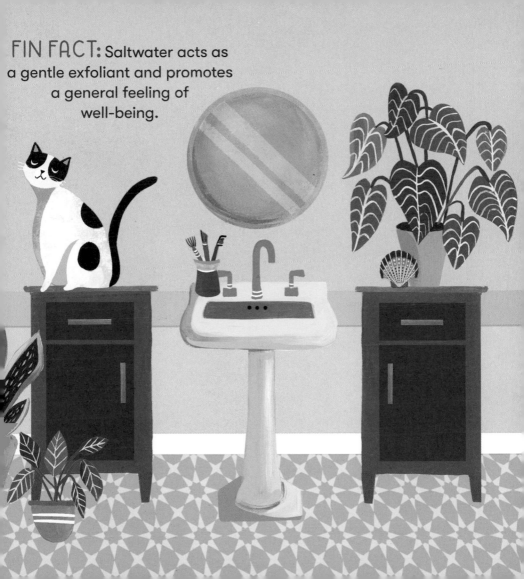

FIN FACT: Saltwater acts as a gentle exfoliant and promotes a general feeling of well-being.

FIN FACT: Aquamarine is named for the Latin phrase *aqua marinus*, meaning "water of the sea." Believed to be formed from mermaids' tears, the stone is said to protect sailors on their voyages and even to prevent seasickness.

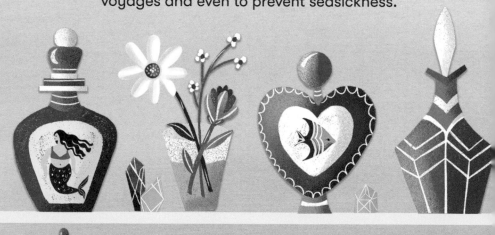

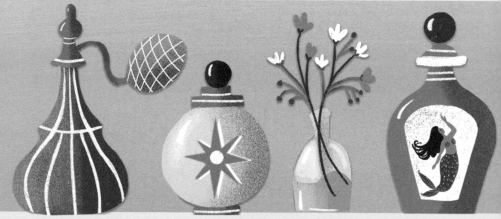

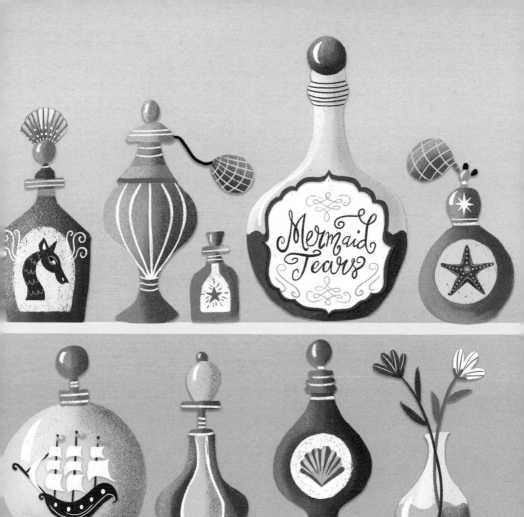

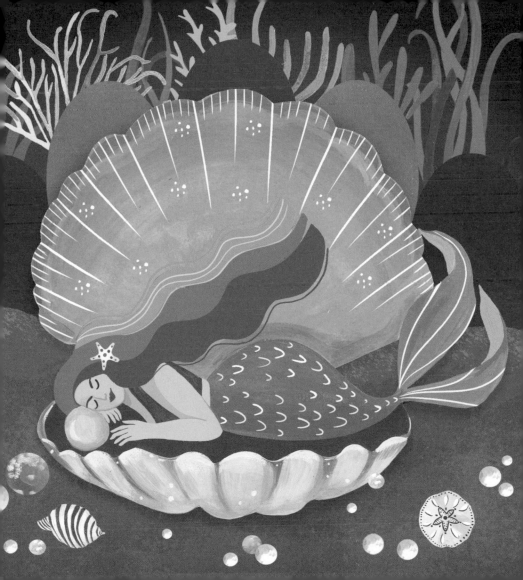

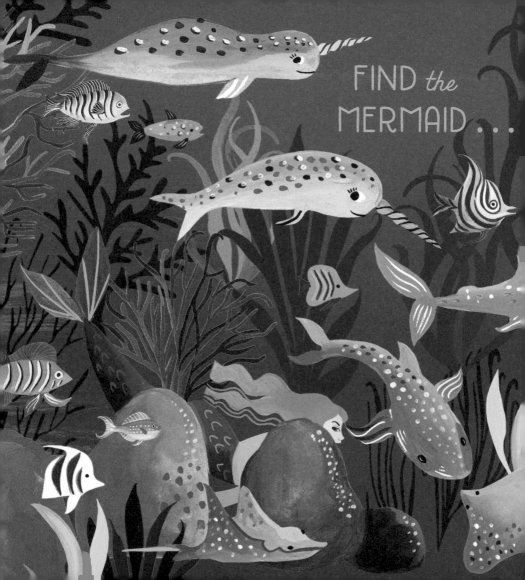

FIND *the* MERMAID ...

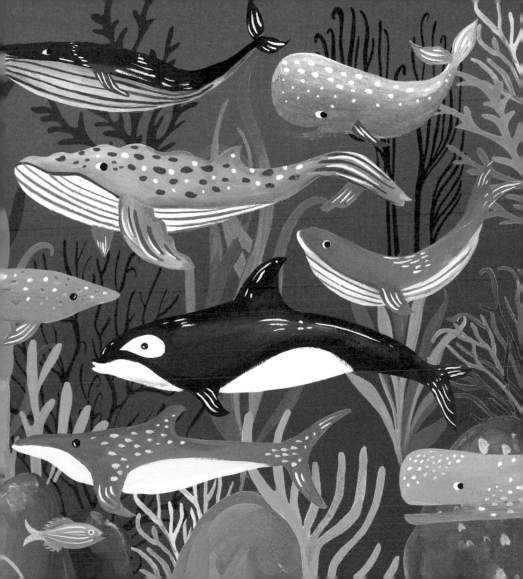

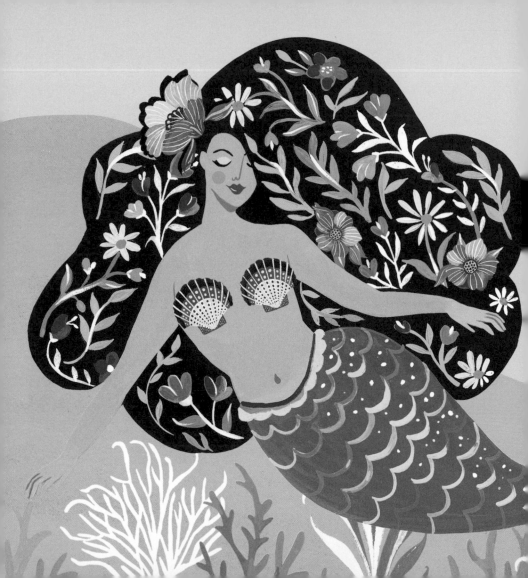

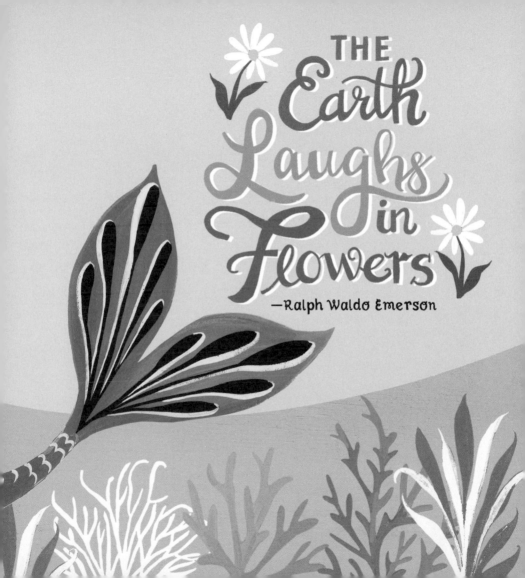

THE *Earth*
Laughs
in
Flowers

—Ralph Waldo Emerson

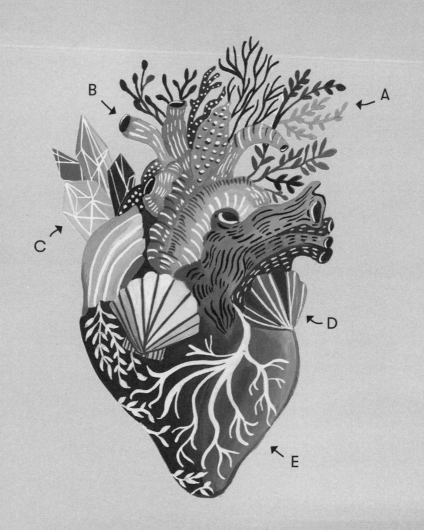

ANATOMY OF A MERMAID'S HEART:

A. Charm

B. Good intentions

C. Magic

D. Mischief

E. Love

PURRRRMAIDS are a girl's best friend!

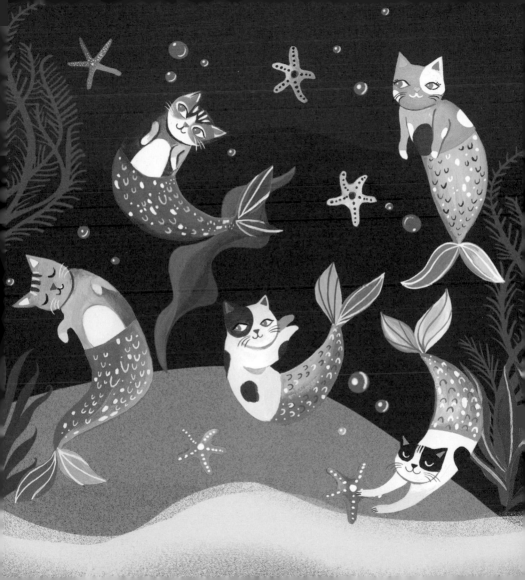

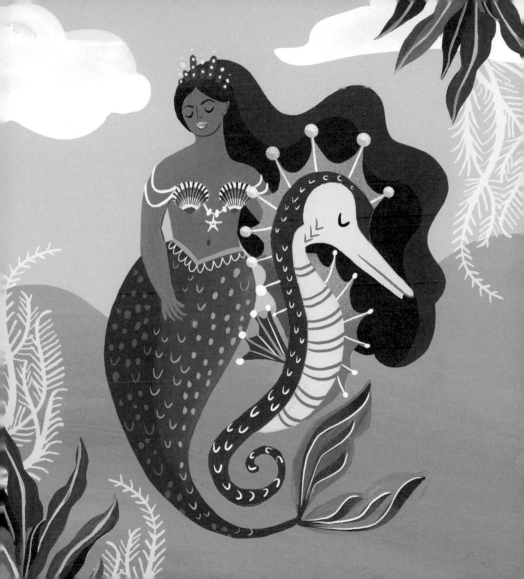

LITOREUS

[lī-'tō-rē-'əs]

1. *noun* Where the shore meets the waves

2. *adjective* Of or belonging to the seashore

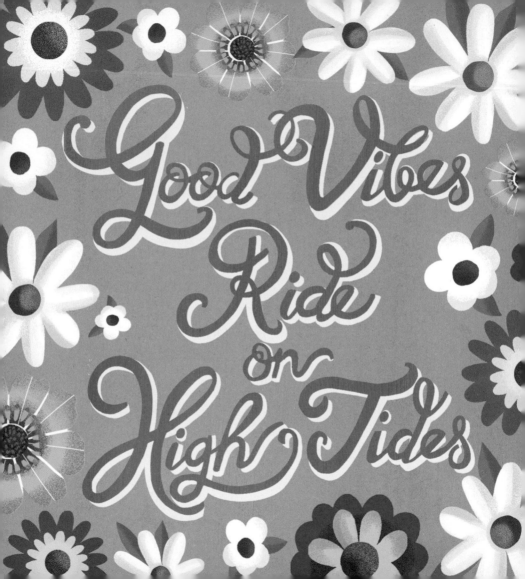

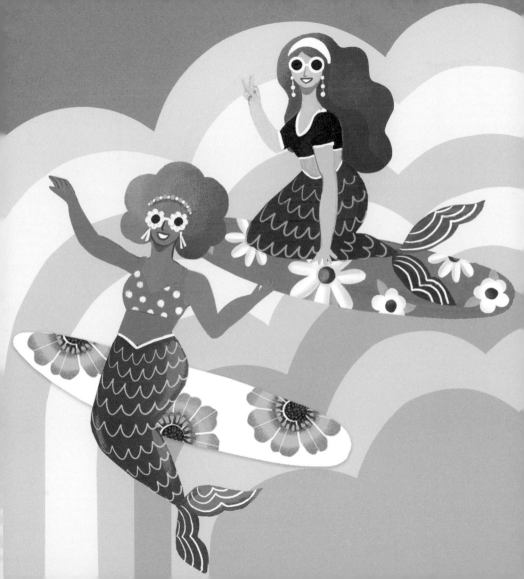

HOW TO LIVE YOUR

BEST *Mermaid* LIFE

Let the currents guide your soul.

Don't let anyone burst your bubble.

Listen to the ocean's song.

Never lose sight of the sea.

Seek magic (and life will offer up its treasures in return).

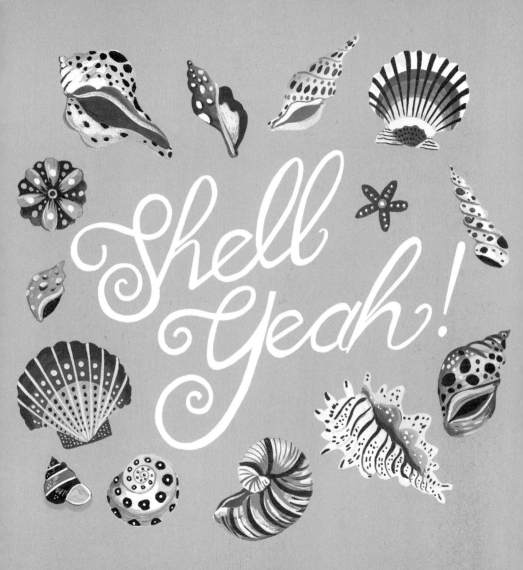

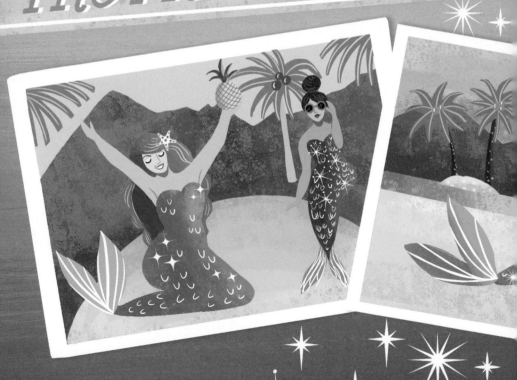

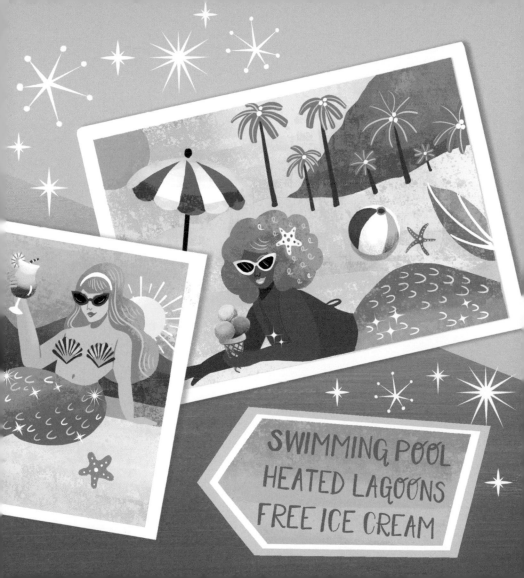

SWIMMING POOL
HEATED LAGOONS
FREE ICE CREAM

How do MERMAIDS SPEND THEIR TIME?

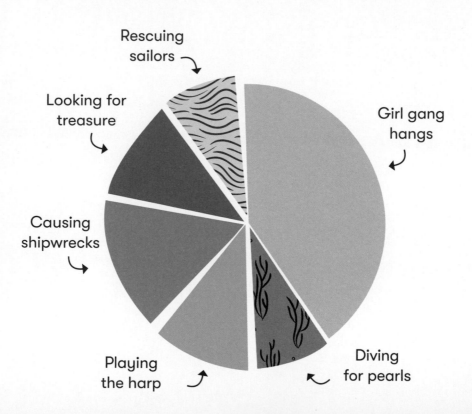

Rescuing sailors

Looking for treasure

Girl gang hangs

Causing shipwrecks

Playing the harp

Diving for pearls

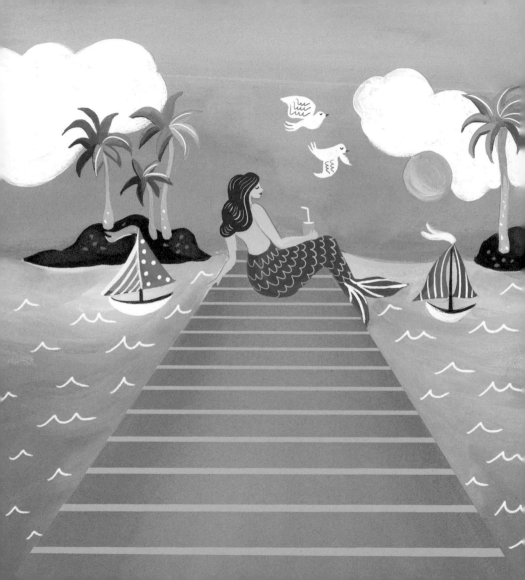

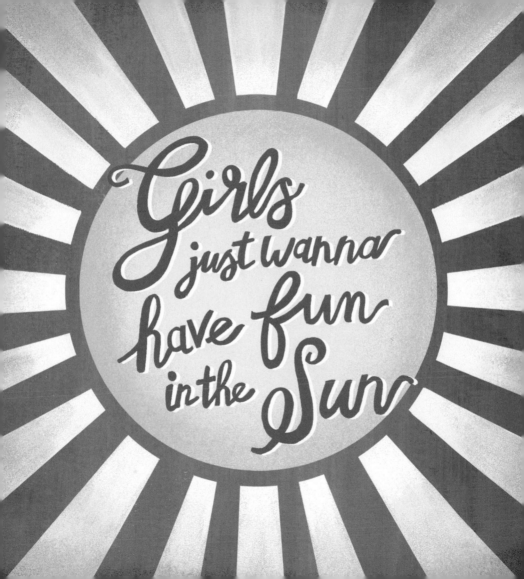

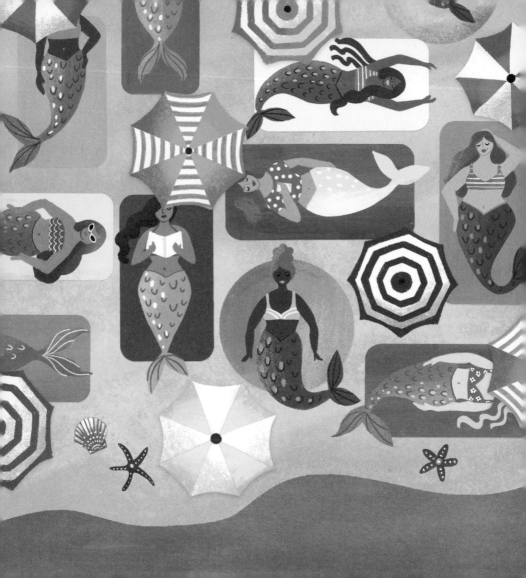

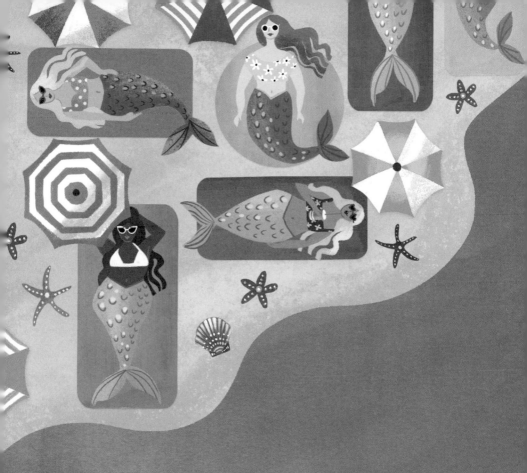

BEACH, PLEASE!

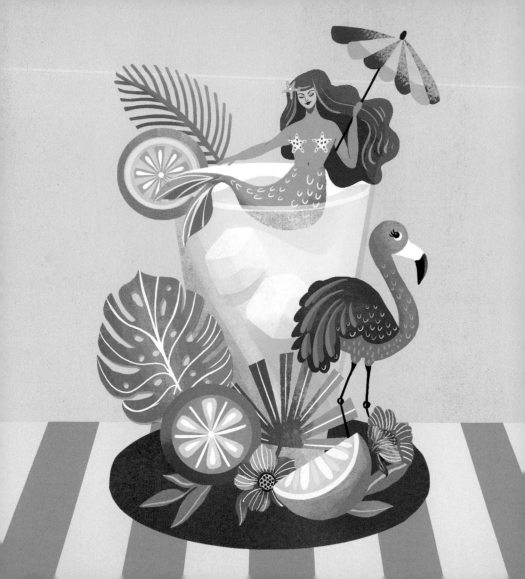

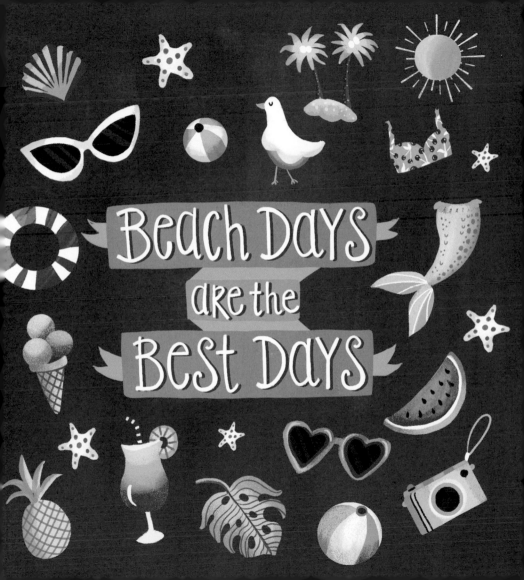

Beach Days are the Best Days

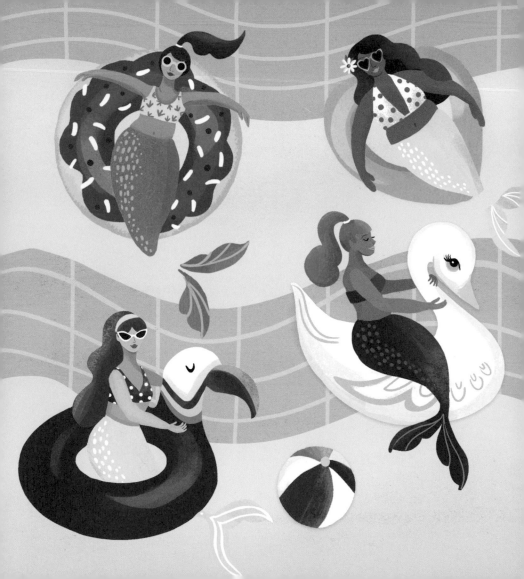

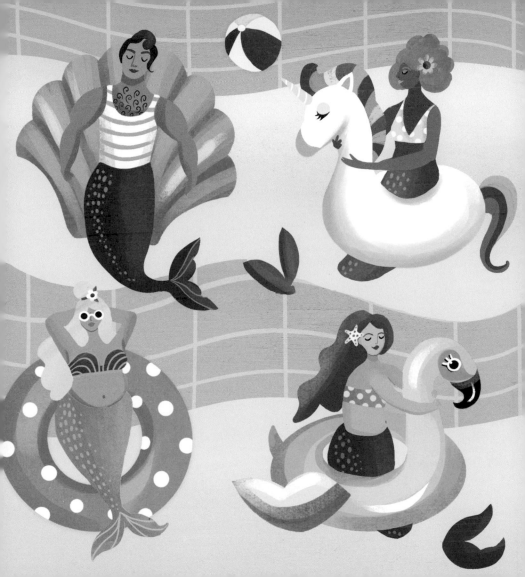

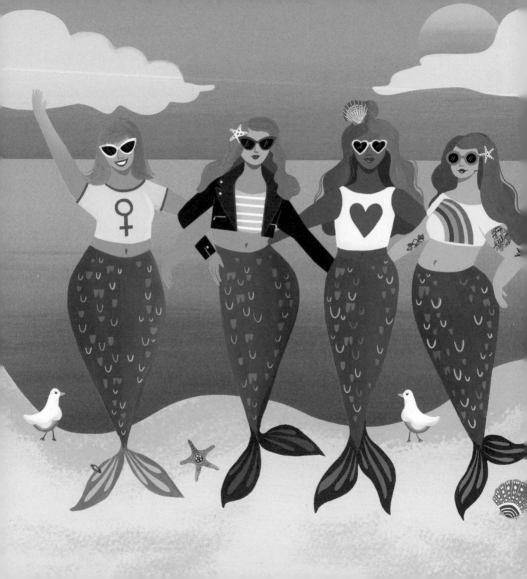

GIRL GANG

[gər(-ə)l gaŋ] *noun*

1. A consortium of fearless, confident women

2. A coven that accomplishes amazing things when working together

3. A sisterhood of badass babes, most often seen cheering each other on

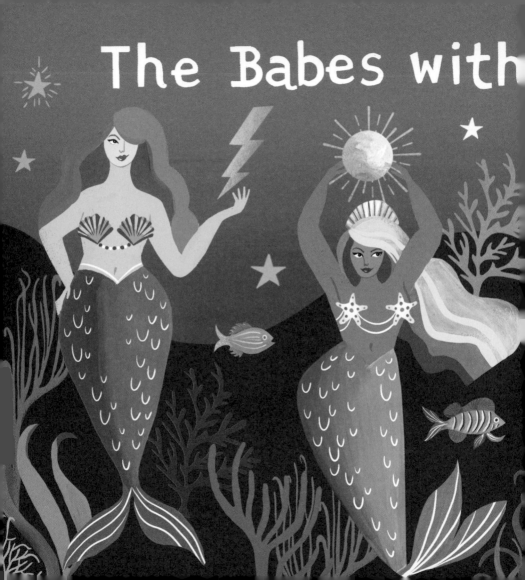

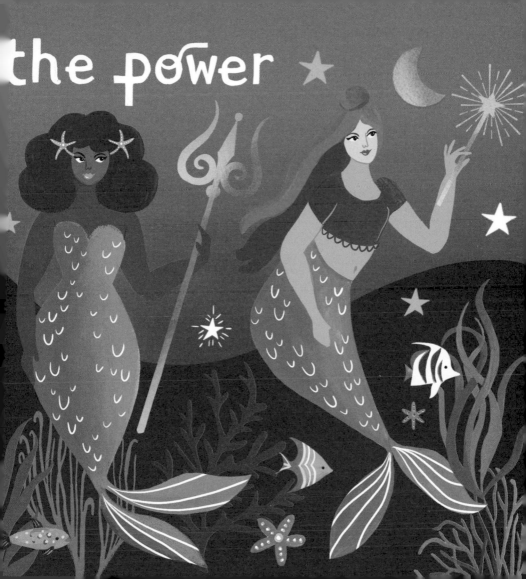

STRONG WOMEN MAKE WAVES

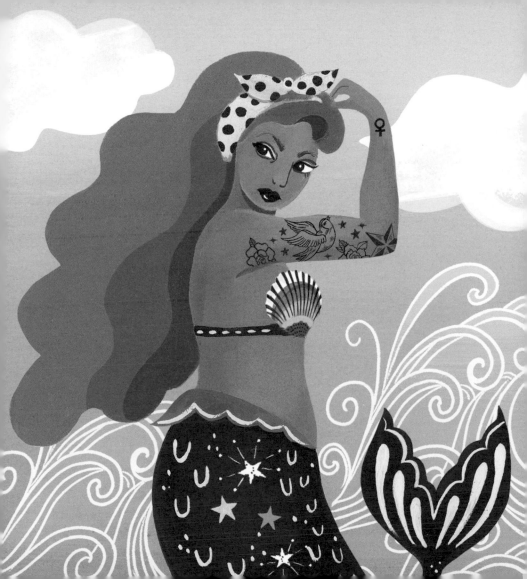

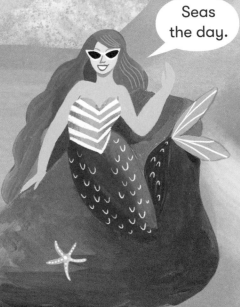

THINGS
MERMAIDS
SAY ...

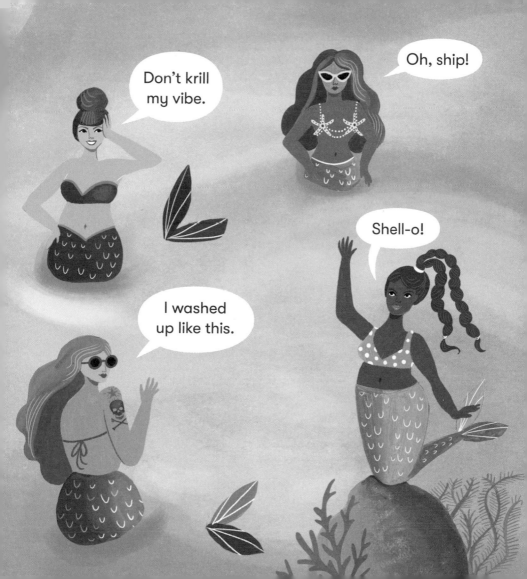

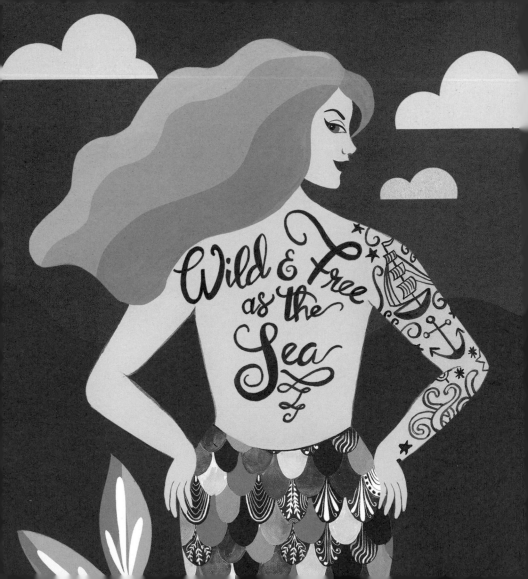

AQUATIC INK

A shark tattoo stands for strength and fearlessness.

Each swallow tattoo represents 5,000 miles sailed.

A tattoo of a mermaid is representative of the enticing dangers of setting out to sea.

A tattoo of a fully rigged ship indicates a sailor who has crossed Cape Horn.

The anchor tattoo signifies a sailor's successful crossing of the Atlantic Ocean.

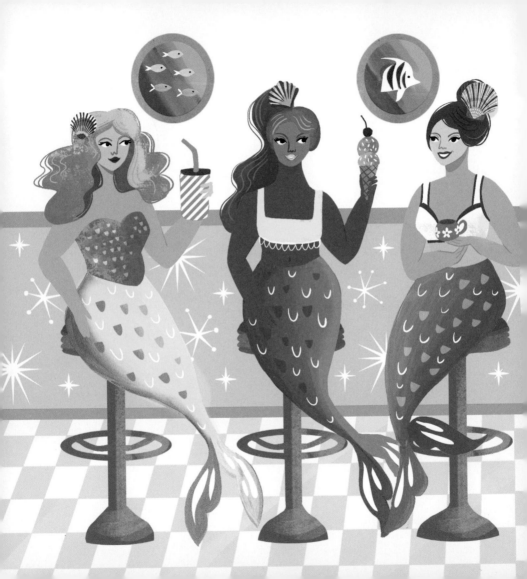

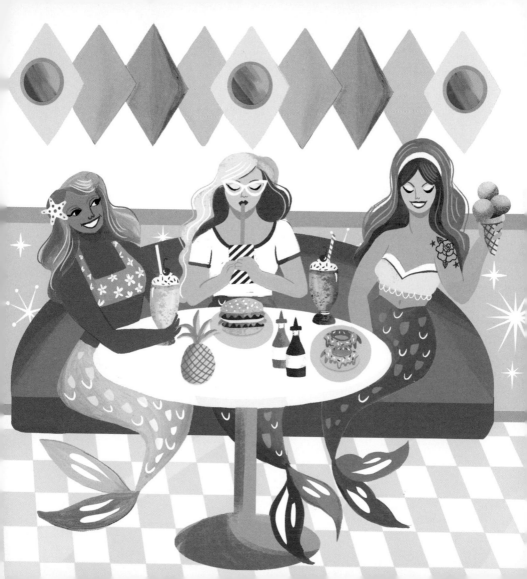

HOW MERMAIDS SHELL-EBRATE

Wear pearls in their hair

Party like a sailor

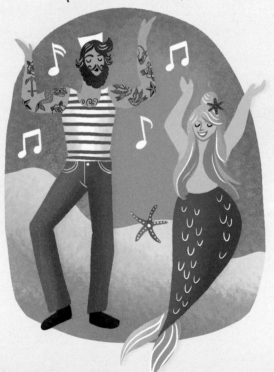

Swim to Hawaii

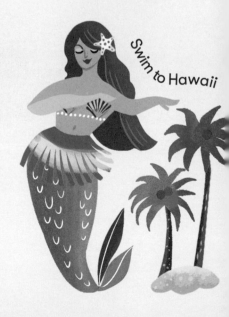

Watch Splash for the 100th time

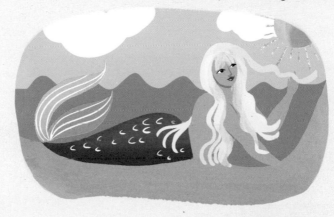

Eat ice cream with sprinkles on top

Play in the waves

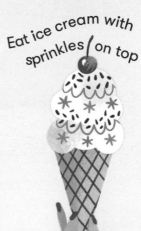

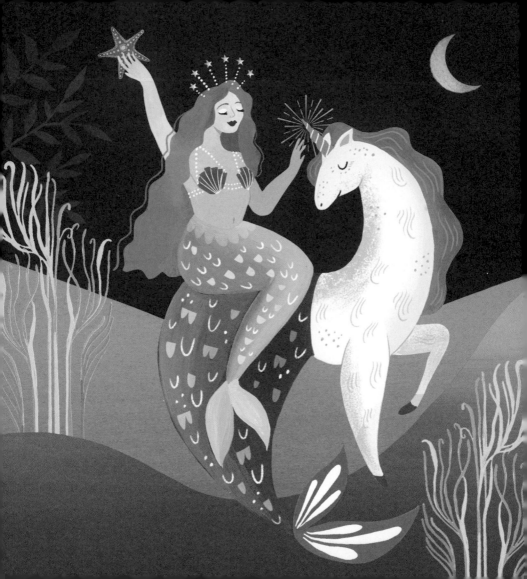

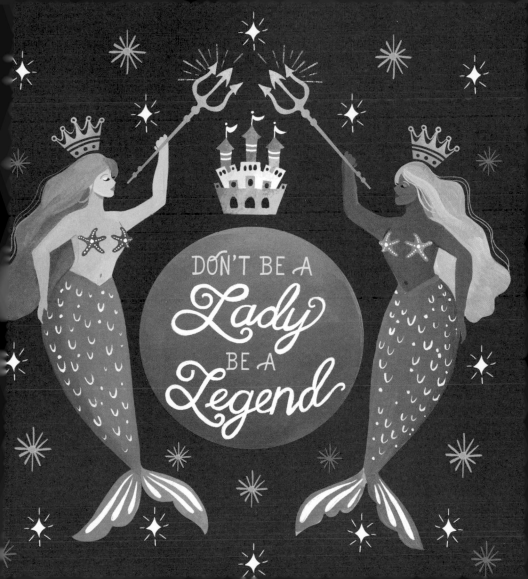

ABOUT THE AUTHOR

CHRISTINE DE CARVALHO is an illustrator and surface pattern designer based in sunny Southern California. Christine studied textile design at the Academy of Art University in San Francisco, California, and the Studio Berçot in Paris, France. She spent six years in Paris developing textile prints for haute couture houses before returning to the States. Now, Christine focuses on her love of painting and illustration and has collaborated with Trader Joe's, American Greetings, John Galliano, and Christian Lacroix. Christine lives with her husband and cats in Los Angeles.

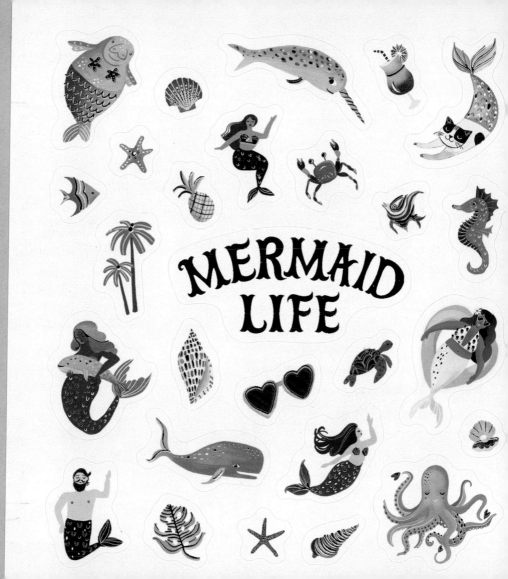

MERMAID
LIFE